The

AIRBRUSH ARTIST'S POCKET PALETTE

Practical, visual advice on
how to render over 300
effects and textures

Mark Taylor

NORTH LIGHT BOOKS

Cincinnati, Ohio

CONTENTS

A QUARTO BOOK

Copyright © 1996
Quarto Inc

First published in the
U.S.A. by North Light
Books, an imprint of
F&W Publications, Inc,
1507 Dana Avenue,
Cincinnati, Ohio
45207
(800) 289-0963

ISBN 0-89134-757-7

This book was
designed and
produced by
Quarto Publishing plc
The Old Brewery
6 Blundell Street
London N7 9BH

While every care has
been taken with the
printing of the color
charts, the publishers
cannot guarantee
total accuracy in
every case.
Printed in China

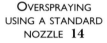

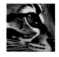

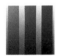
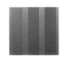

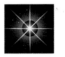

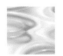

4 HOW TO USE THIS BOOK

THE AIM OF THIS BOOK is to provide the artist with a straightforward at-a-glance guide to color mixtures and effects which can be achieved with an airbrush, and to avoid the time-consuming trial-and-error method which might otherwise be involved.

USING THE CHARTS

The charts in this book have been designed as an introduction to the wide range of useful effects available to the artist using an airbrush. Color combinations using both opaque and transparent pigments have been explored, spraying both with standard and splattercap nozzles. The two examples, below, illustrate some of the parameters used throughout the book.

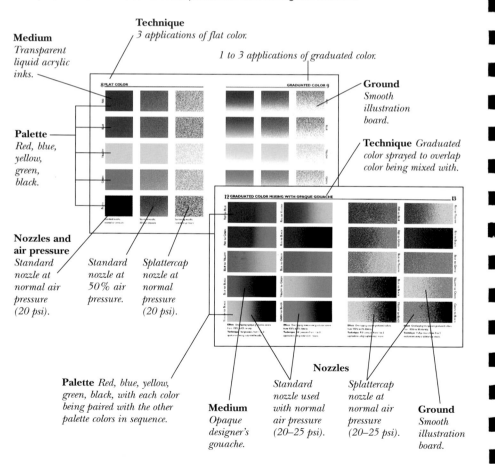

Technique
3 applications of flat color.

1 to 3 applications of graduated color.

Medium
Transparent liquid acrylic inks.

Ground
Smooth illustration board.

Palette
Red, blue, yellow, green, black.

Technique *Graduated color sprayed to overlap color being mixed with.*

Nozzles and air pressure
Standard nozzle at normal air pressure (20 psi).

Standard nozzle at 50% air pressure.

Splattercap nozzle at normal pressure (20 psi).

Nozzles

Palette *Red, blue, yellow, green, black, with each color being paired with the other palette colors in sequence.*

Medium
Opaque designer's gouache.

Standard nozzle used with normal air pressure (20–25 psi).

Splattercap nozzle at normal air pressure (20–25 psi).

Ground
Smooth illustration board.

GROUNDS

The surface onto which pigment is sprayed—the ground—can be varied to achieve a desired effect. The range of possibilities for usable surfaces is very wide and a selection is shown in this book. Most surfaces will need to be cleaned and/or primed before use but experimentation can give some surprising and useful effects.

PAINTS

Virtually all of the traditional painting pigments can be used in an airbrush, provided that they have been suitably prepared/diluted. Watercolors, designer's gouache, and liquid acrylic inks are three of the most commonly used pigments, and are least likely to cause blockages or cleaning problems with the airbrush.

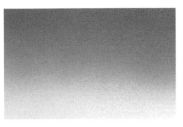

Smooth board for crisp, sharp, flat tints. Good for technical or photorealistic work.

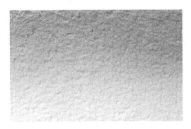

Watercolor paper creates a mottled effect. Gives a looser, impressionistic feel.

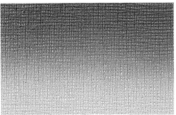

Primed fabric for a textured finish.

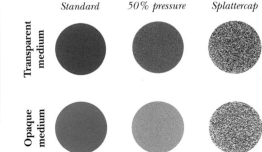

Watercolors for vibrant transparent effects.

Designer's gouache for overlaying colors and opaque effects.

Liquid acrylic inks for bright transparent colors. Not so fugitive as watercolor, and waterproof too.

NOZZLES

The standard nozzle size of an airbrush may vary with different manufacturers, some being designed for very fine close-up detail work and others more suitable for spraying across large areas. A splattercap nozzle literally splatters paint from the airbrush and is particularly useful for textural work. Both types of nozzle and their effects are demonstrated in this book.

	Standard	Standard 50% pressure	Splattercap
Transparent medium	●	●	●
Opaque medium	●	●	●

In this book transparent opaque colors are demonstrated in both flat and graduated tonal applications. The effects of overspraying with opaque color and glazing with transparent color are explored, with each of the palette colors being shown as a base color and as an oversprayed color.

Red

COLOR PALETTE

A basic palette of red, blue, yellow, green, and black was chosen to demonstrate the wide variety of color and tonal effect which can be achieved, and is intended as a starting point for further experimentation by the artist wishing to use an alternative palette of secondary and tertiary colors.

Blue

red *yellow*

COLOR MIXING

Mixing color in the palette before spraying—atomic mixing—is useful when a precise color is required. Color can also be mixed optically, whereby colors are juxtaposed on the artwork surface and are "mixed" by eye. These possibilities are explored in the overspraying opaque and transparent color charts.

Colors before mixing

Yellow

Green

Color mixed before spraying.
Atomic mixing

Colors mixed by
overspraying:
Optical mixing

Black

Overspraying layers of transparent color to increase tonal strength.

To develop tonal variation, an area can be repeatedly oversprayed with transparent color. This is particularly useful when building form in order to give a three-dimensional quality to a subject, and is demonstrated in this book using flat, gradated, and splattered color.

One layer of color.

Two layers produce a third tone.

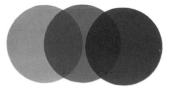

Three layers produce five tonal areas.

OVERLAPPING COLOR

Overlapping transparent colors.

Overlapping transparent color, or glazing, is useful for producing very subtle color mixtures and graduations in which previously sprayed layers of color can still be seen through the top layer of color and are mixed optically. Opaque color can be used to hide a previously sprayed color, or used as a semi-opaque overspray, or scumble, partially to mask or knock back an area of color.

Overlapping opaque colors.

GRADATED WASH

The ability of the airbrush to apply a flawless graduation of paint is one of its main attributes. When combined with color mixing and texturing, a great variety of effects can be achieved, and the examples offered in this book may be seen as a starting point for further experimentation.

Basic graduation

Graduated color on previously sprayed color

Graduated color on textured color

8 FLAT COLOR

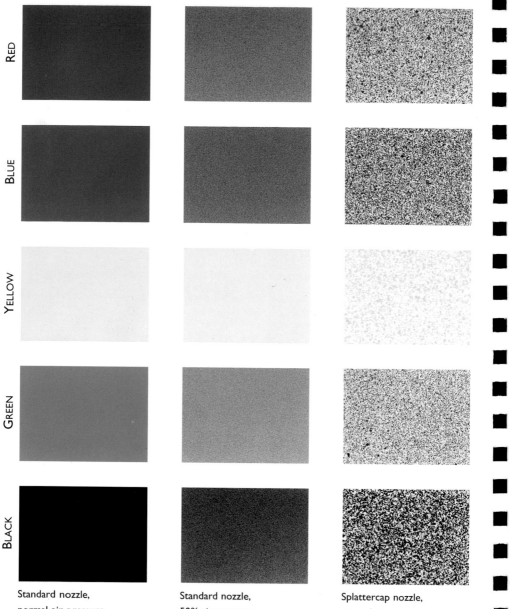

RED
BLUE
YELLOW
GREEN
BLACK

Standard nozzle,
normal air pressure

Standard nozzle,
50% air pressure

Splattercap nozzle,
normal air pressure

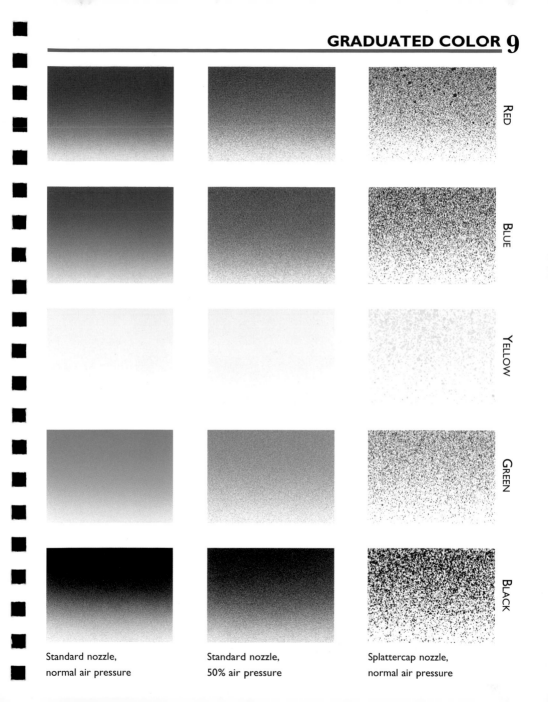

RED

BLUE

YELLOW

GREEN

BLACK

Standard nozzle,
normal air pressure

Standard nozzle,
50% air pressure

Splattercap nozzle,
normal air pressure

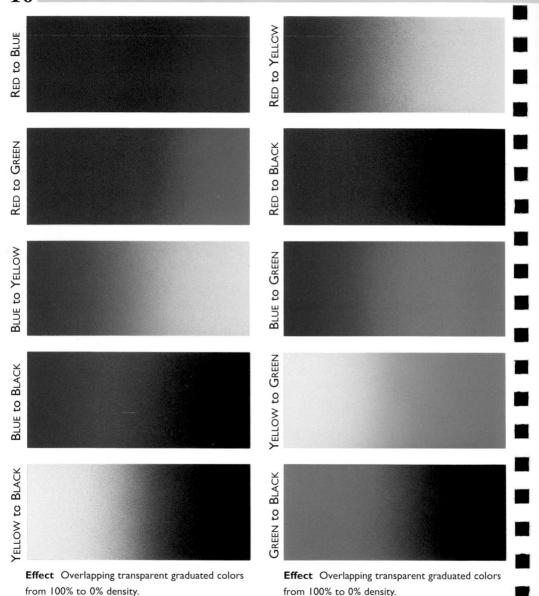

RED to BLUE

RED to YELLOW

RED to GREEN

RED to BLACK

BLUE to YELLOW

BLUE to GREEN

BLUE to BLACK

YELLOW to GREEN

YELLOW to BLACK

GREEN to BLACK

Effect Overlapping transparent graduated colors from 100% to 0% density.

Technique Full pressure from 1 to 3 applications using a standard nozzle.

Effect Overlapping transparent graduated colors from 100% to 0% density.

Technique Full pressure from 1 to 3 applications using a standard nozzle.

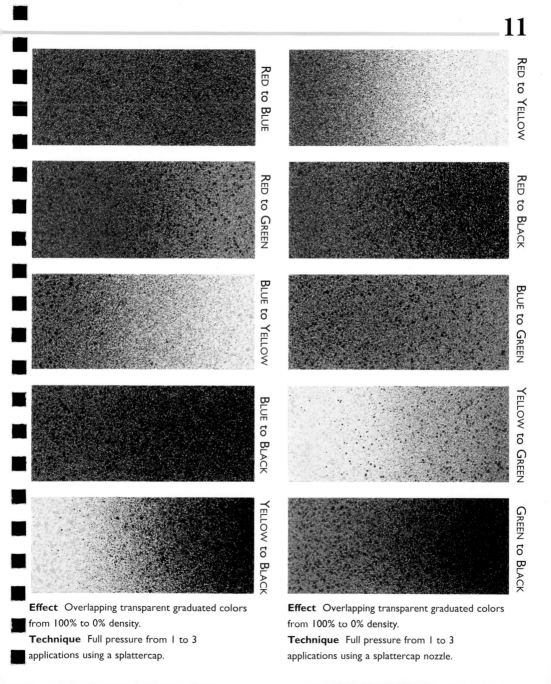

RED to BLUE

RED to YELLOW

RED to GREEN

RED to BLACK

BLUE to YELLOW

BLUE to GREEN

BLUE to BLACK

YELLOW to GREEN

YELLOW to BLACK

GREEN to BLACK

Effect Overlapping transparent graduated colors from 100% to 0% density.

Technique Full pressure from 1 to 3 applications using a splattercap.

Effect Overlapping transparent graduated colors from 100% to 0% density.

Technique Full pressure from 1 to 3 applications using a splattercap nozzle.

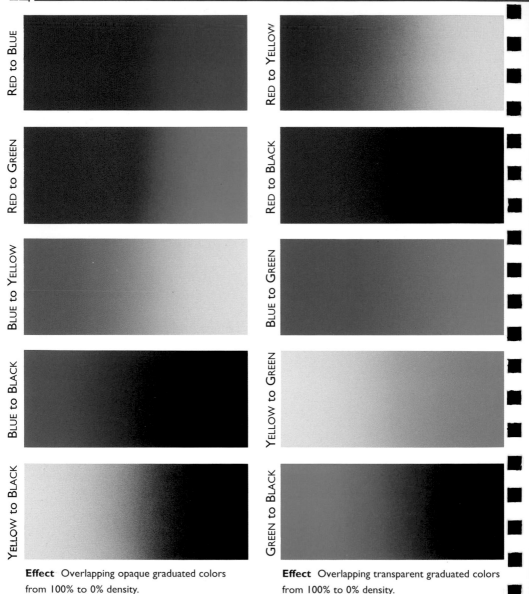

RED to BLUE

RED to YELLOW

RED to GREEN

RED to BLACK

BLUE to YELLOW

BLUE to GREEN

BLUE to BLACK

YELLOW to GREEN

YELLOW to BLACK

GREEN to BLACK

Effect Overlapping opaque graduated colors from 100% to 0% density.

Technique Full pressure from 1 to 3 applications using a standard nozzle.

Effect Overlapping transparent graduated colors from 100% to 0% density.

Technique Full pressure from 1 to 3 applications using a standard nozzle.

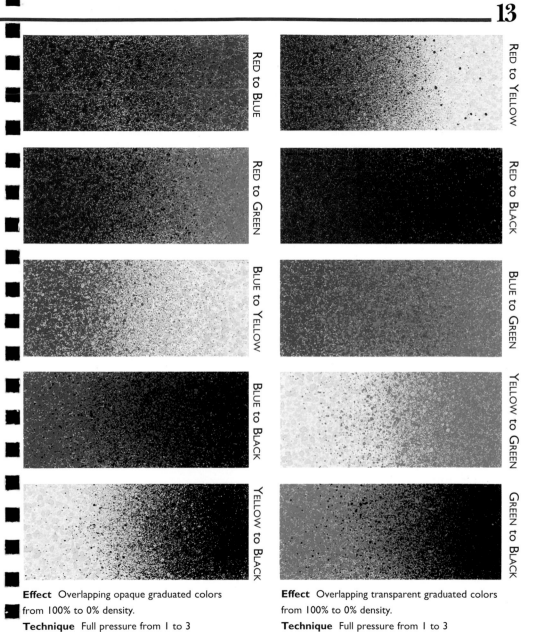

RED to BLUE

RED to YELLOW

RED to GREEN

RED to BLACK

BLUE to YELLOW

BLUE to GREEN

BLUE to BLACK

YELLOW to GREEN

YELLOW to BLACK

GREEN to BLACK

Effect Overlapping opaque graduated colors from 100% to 0% density.

Technique Full pressure from 1 to 3 applications using a splattercap nozzle.

Effect Overlapping transparent graduated colors from 100% to 0% density.

Technique Full pressure from 1 to 3 applications using a splattercap nozzle.

14 OVERSPRAYING USING A STANDARD NOZZLE

NORMAL BASE

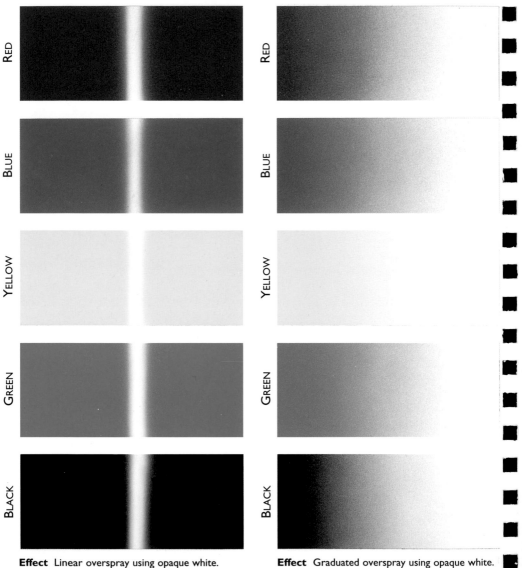

Effect Linear overspray using opaque white.
Technique 3 applications at full pressure using a standard nozzle.

Effect Graduated overspray using opaque white.
Technique 1 to 3 applications at full pressure using a standard nozzle.

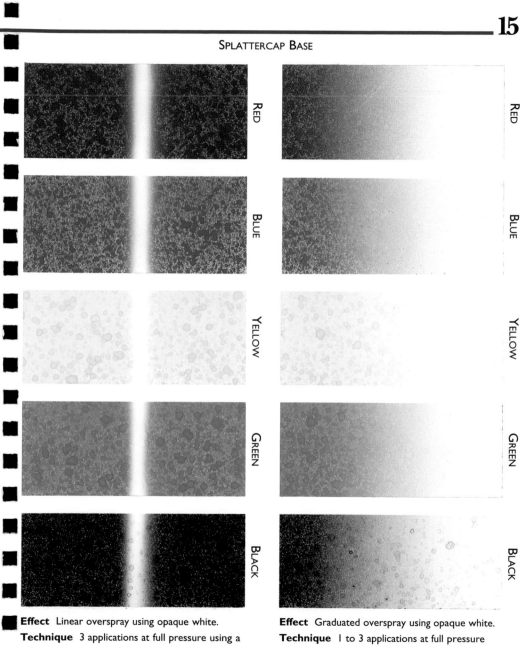

SPLATTERCAP BASE

RED
BLUE
YELLOW
GREEN
BLACK

Effect Linear overspray using opaque white.
Technique 3 applications at full pressure using a standard nozzle.

Effect Graduated overspray using opaque white.
Technique 1 to 3 applications at full pressure using a standard nozzle.

NORMAL BASE

RED

BLUE

YELLOW

GREEN

BLACK

Effect Linear overspray using opaque white.
Technique 3 applications at full pressure using a splattercap nozzle.

Effect Graduated overspray using opaque white.
Technique 1 to 3 applications at full pressure using a splattercap nozzle.

SPLATTERCAP BASE

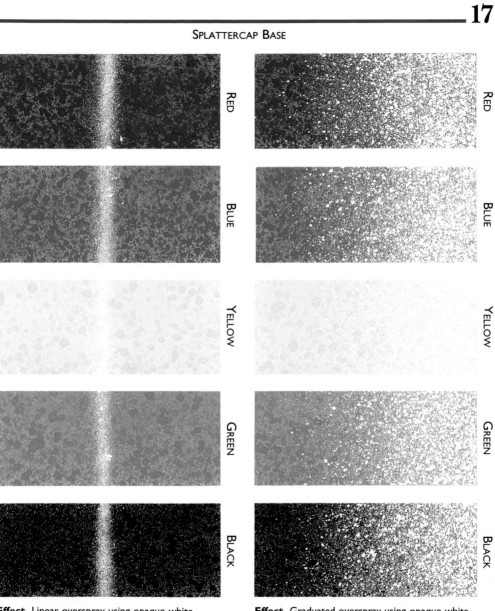

RED
RED
BLUE
BLUE
YELLOW
YELLOW
GREEN
GREEN
BLACK
BLACK

Effect Linear overspray using opaque white.
Technique 3 applications at full pressure using a splattercap nozzle.

Effect Graduated overspray using opaque white.
Technique 1 to 3 applications at full pressure using a splattercap nozzle.

Adrian Chesterman – *Dinosaur World*

IN THIS PAINTING, which contains a wealth of detail, the artist has been meticulous in the depiction of surface texture and form, with combinations of overspraying and erasing techniques being employed. The landscape has also been given depth by use of both linear and aerial perspective, which has helped to separate the various elements in the composition.

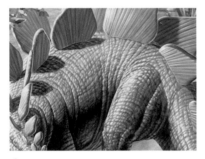

▲ *The surface detail of the dinosaur's skin has been achieved by the multiple overspraying of transparent medium, with the airbrush nozzle kept close to the support, and highlights reinforced with an eraser.*

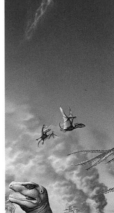

◀ *The wispy clouds and the more substantial smoke from the volcanoes have been sprayed freehand using opaque whites and grays over the previously painted blue sky.*

▼ *The surface texture and linear detail in this group has been built up with transparent pigment overspray, with the highlights and texturing scratched back with a blade.*

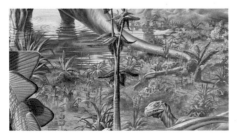

▲ *The animals have been brought forward by knocking back the background with a subtle semi-opaque overspray of white, which was sprayed whilst the animals were temporarily masked.*

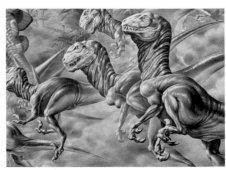

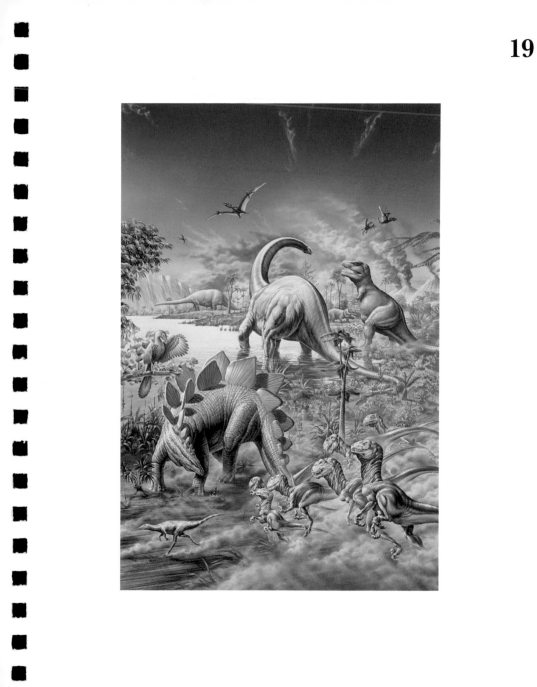

20 OPAQUE COLOR SPLATTER

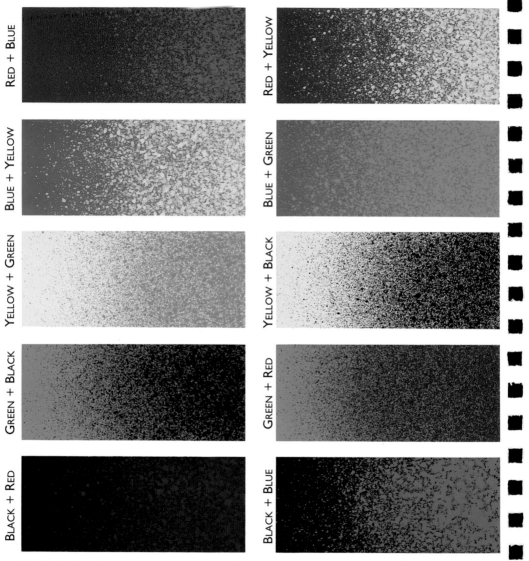

RED + BLUE

RED + YELLOW

BLUE + YELLOW

BLUE + GREEN

YELLOW + GREEN

YELLOW + BLACK

GREEN + BLACK

GREEN + RED

BLACK + RED

BLACK + BLUE

Effect Graduated overspray using opaque gouache.

Technique Opaque base color applied at full pressure, 3 applications using a standard nozzle.

Graduated opaque color overspray applied at full pressure, 1 to 3 applications using a splattercap nozzle.

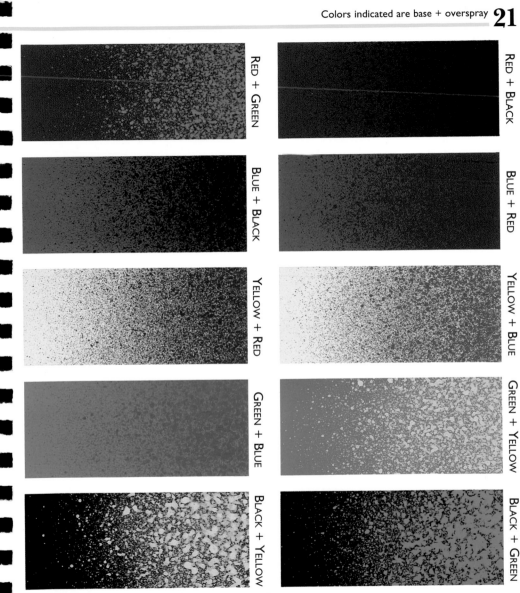

Effect Graduated overspray using opaque gouache.

Technique Opaque base color applied at full pressure, 3 applications using a standard nozzle.

Graduated opaque color overspray applied at full pressure, I to 3 applications using a splattercap nozzle.

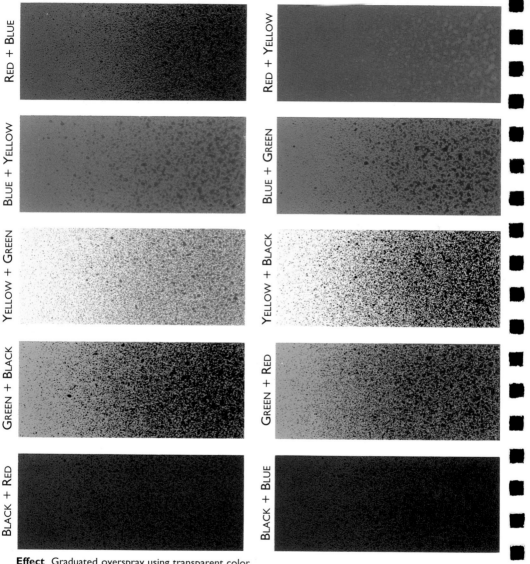

RED + BLUE

RED + YELLOW

BLUE + YELLOW

BLUE + GREEN

YELLOW + GREEN

YELLOW + BLACK

GREEN + BLACK

GREEN + RED

BLACK + RED

BLACK + BLUE

Effect Graduated overspray using transparent color.

Technique Transparent base color at 50% strength, 3 applications using a standard nozzle.

Graduated color at 50% strength applied at full pressure, 1 to 3 applications using a splattercap nozzle.

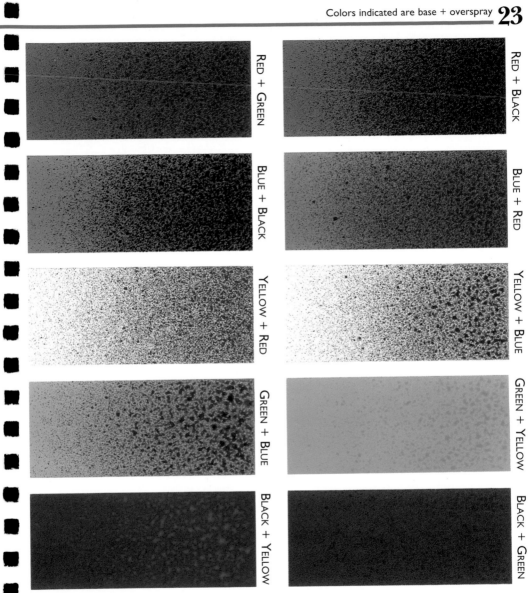

RED + GREEN

RED + BLACK

BLUE + BLACK

BLUE + RED

YELLOW + RED

YELLOW + BLUE

GREEN + BLUE

GREEN + YELLOW

BLACK + YELLOW

BLACK + GREEN

Effect Graduated overspray using transparent color.

Technique Transparent base color at 50% strength, 3 applications using a standard nozzle.

Graduated color at 50% strength applied at full pressure, 1 to 3 applications using a splattercap nozzle.

24 BUILDING FORM: USING A SINGLE FLAT COLOR

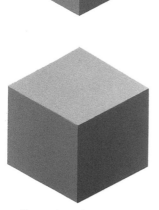

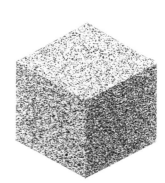

Using a cut-film mask, each area is exposed and sprayed with flat color, in sequence, from dark to light.

Using a cut-film mask, each area is exposed and sprayed with flat color using a splattercap nozzle, in sequence.

STANDARD NOZZLE

SPLATTERCAP NOZZLE

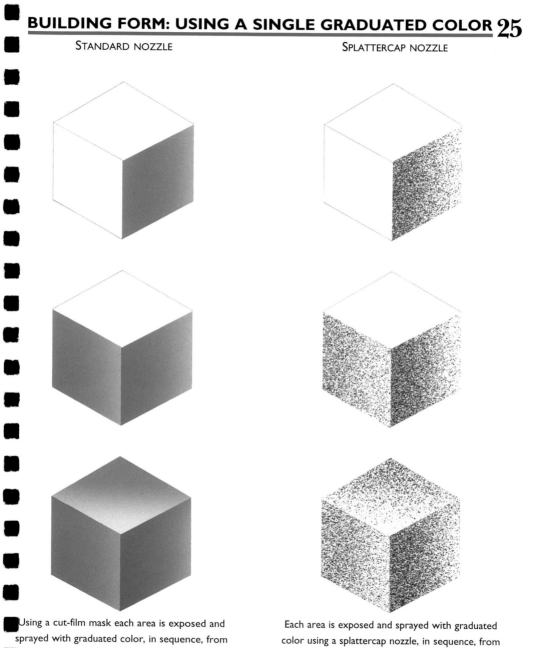

Using a cut-film mask each area is exposed and sprayed with graduated color, in sequence, from dark to light.

Each area is exposed and sprayed with graduated color using a splattercap nozzle, in sequence, from dark to light.

STANDARD NOZZLE

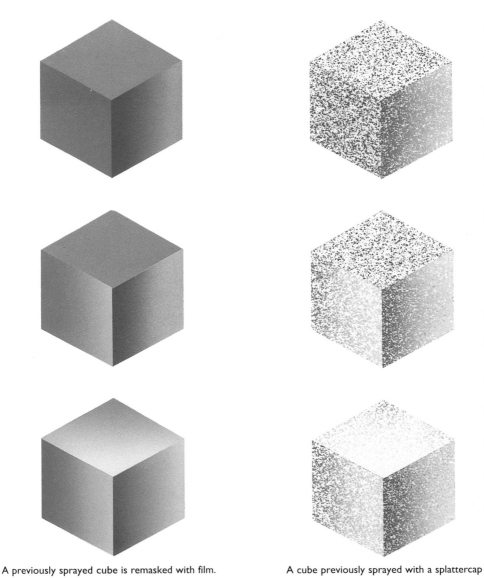

A previously sprayed cube is remasked with film. Each area is oversprayed in sequence with graduated opaque white.

A cube previously sprayed with a splattercap nozzle is remasked and each area oversprayed in sequence.

SPLATTERCAP NOZZLE

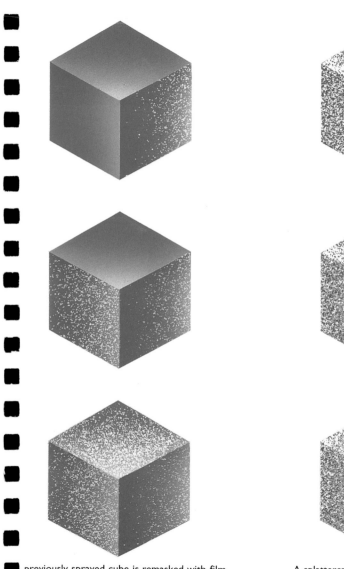

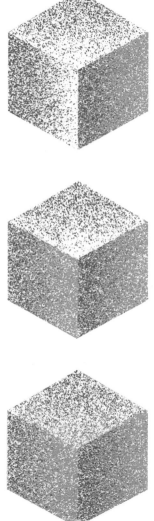

previously sprayed cube is remasked with film.
Each area is oversprayed in sequence with
graduated opaque white.

A splattercapped cube is remasked with film.
Each area is oversprayed in sequence with a
second color.

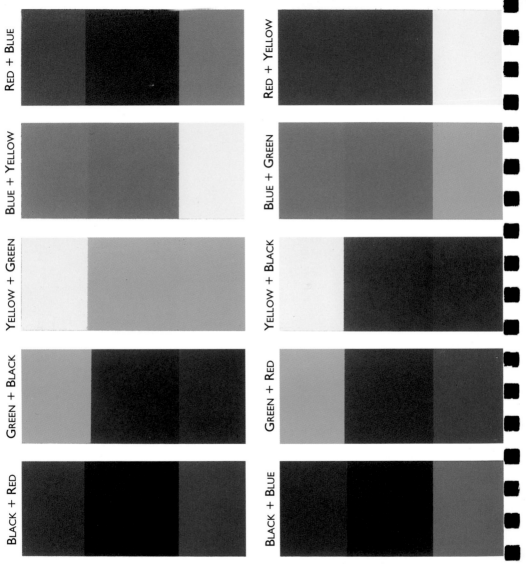

RED + BLUE

RED + YELLOW

BLUE + YELLOW

BLUE + GREEN

YELLOW + GREEN

YELLOW + BLACK

GREEN + BLACK

GREEN + RED

BLACK + RED

BLACK + BLUE

Effect Overlapping transparent colors.

Technique Transparent base color at 50% strength, 3 applications using a standard nozzle.

Overlapping transparent color at 50% strength applied at full pressure, 3 applications using a standard nozzle.

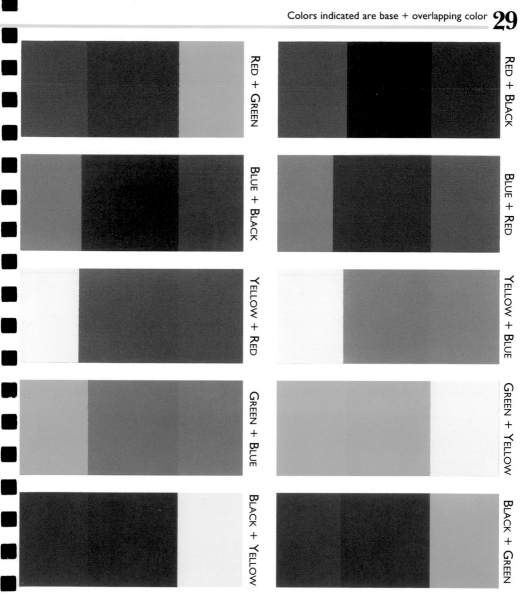

RED + GREEN

RED + BLACK

BLUE + BLACK

BLUE + RED

YELLOW + RED

YELLOW + BLUE

GREEN + BLUE

GREEN + YELLOW

BLACK + YELLOW

BLACK + GREEN

Effect Overlapping transparent colors.

Technique Transparent base color at 50% strength, 3 applications using a standard nozzle.

Overlapping transparent color at 50% strength applied at full pressure, 3 applications using a standard nozzle.

Greg Hurley – *Ocelot*

IN THIS GRAPHIC COMPOSITION, an effectively out-of-focus background has been used to throw the profile of the ocelot into striking relief and emphasize the texture of the animal's coat. The green of the background also provides a good contrast to the warm colors used in the painting of the animal.

▲ *After initially masking the animal's head and shoulders, freehand spraying has been used to build up the background color, with dark green overspraying and stippling on a previously sprayed lighter green.*

▶ *Over a previously sprayed graduated area of light yellow ocher, the texture of the animal's fur has been suggested with freehand overspraying of medium-warm browns, while keeping the airbrush nozzle close to the support.*

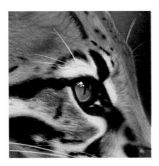

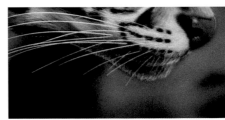

◀ *Cut-film masking has been used to preserve the clarity of the eye color, while the dark areas of fur were being sprayed, then the eye highlights were scratched back with a scalpel blade.*

▲ *The soft highlights in the fur have been reinforced with an eraser, whilst the whiskers and the fur texture on the chin have been scratched back and reinforced with opaque color.*

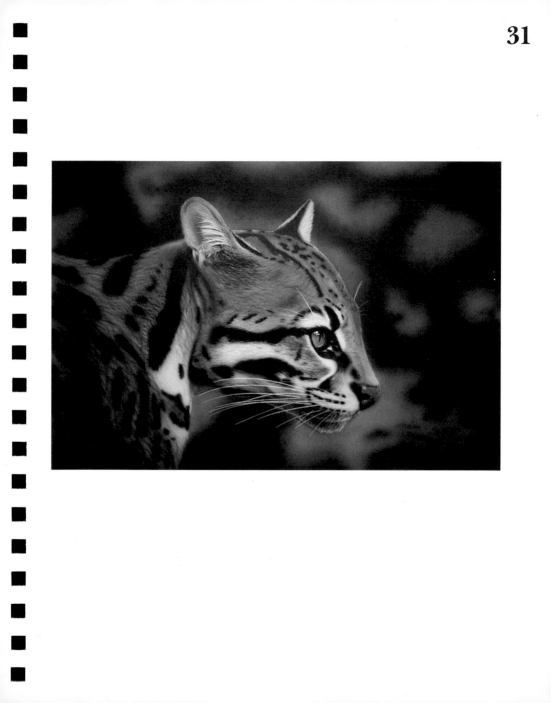

32 OVERSPRAY WITH GRADUATED TRANSPARENT RED

BASE COLOR: BLUE BASE COLOR: YELLOW

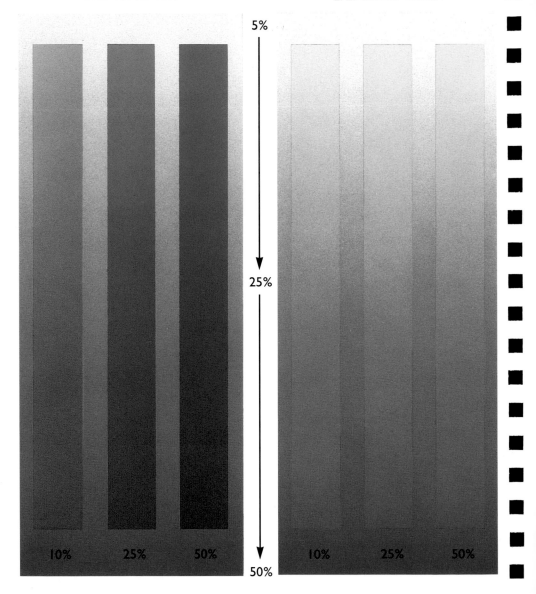

5%

25%

50%

10% 25% 50% 10% 25% 50%

Percentage base colors are oversprayed with transparent red which graduates in density from 5% to 50%.

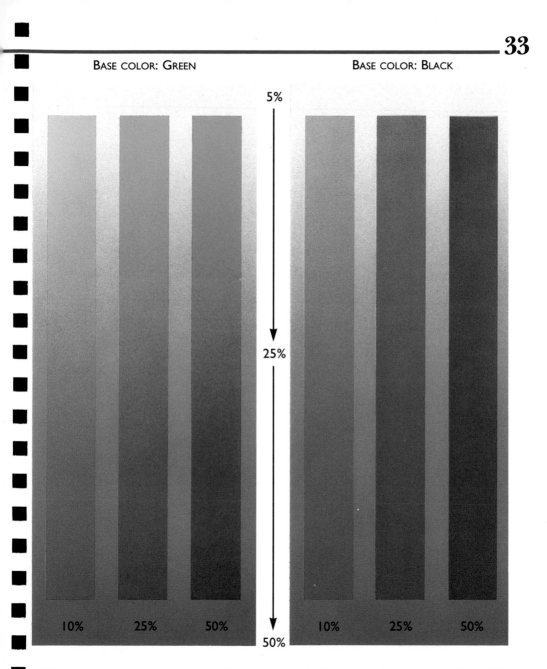

BASE COLOR: GREEN

BASE COLOR: BLACK

5%

25%

50%

10% 25% 50% 10% 25% 50%

Percentage base colors are oversprayed with transparent red which graduates in density from 5% to 50%.

34 OVERSPRAY WITH GRADUATED TRANSPARENT BLUE

BASE COLOR: RED BASE COLOR: YELLOW

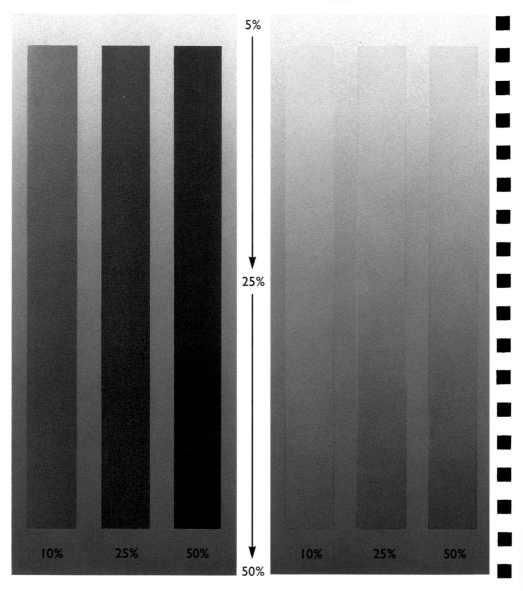

5%

25%

50%

10% 25% 50% 10% 25% 50%

Percentage base colors are oversprayed with transparent blue which graduates in density from 5% to 50%.



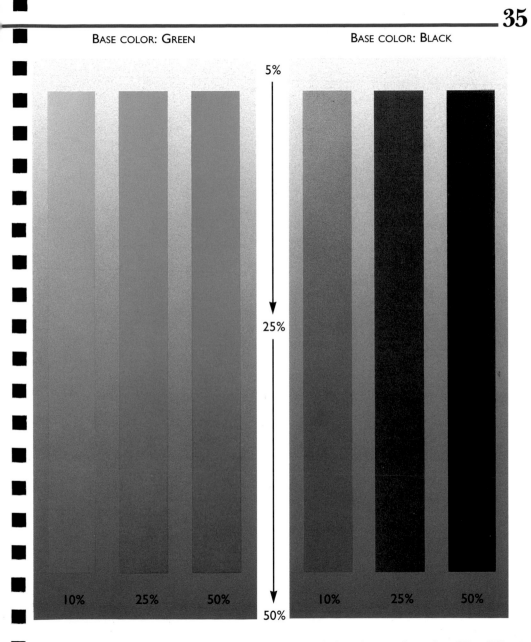

Percentage base colors are oversprayed with transparent blue which graduates in density from 5% to 50%.

BASE COLOR: RED

BASE COLOR: BLUE

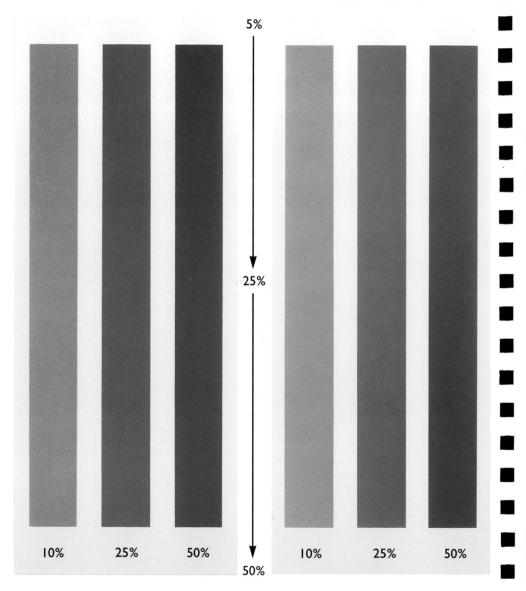

5%

25%

50%

| 10% | 25% | 50% | | 10% | 25% | 50% |

Percentage base colors are oversprayed with transparent yellow which graduates in density from 5% to 50%.

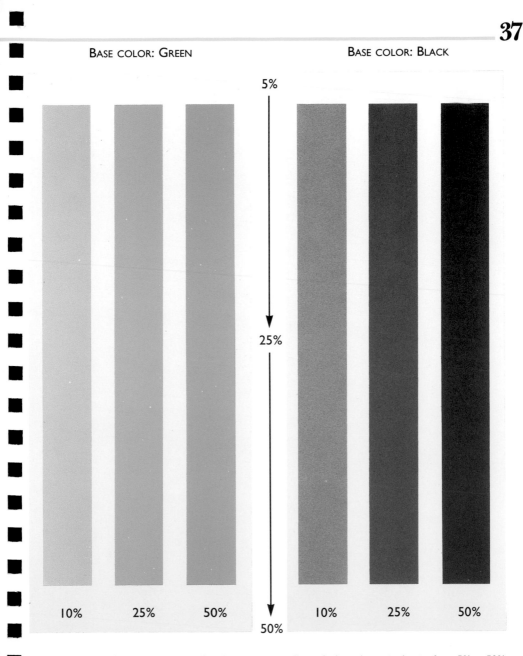

BASE COLOR: GREEN

BASE COLOR: BLACK

5%

25%

50%

10% 25% 50%

10% 25% 50%

Percentage base colors are oversprayed with transparent yellow which graduates in density from 5% to 50%.

38 OVERSPRAY WITH GRADUATED TRANSPARENT GREEN

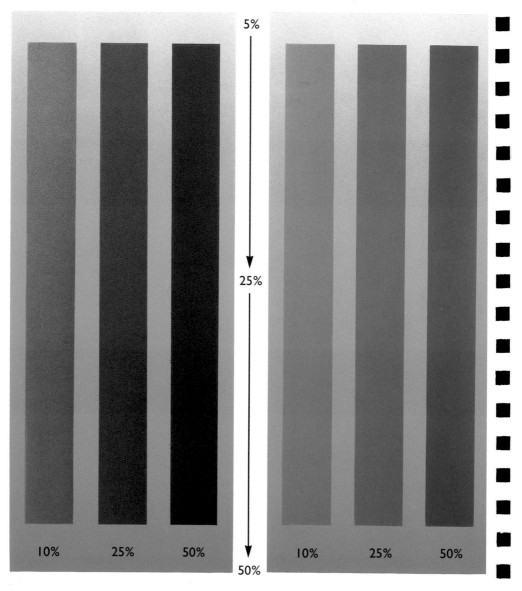

BASE COLOR: RED

BASE COLOR: BLUE

5%

25%

50%

10% 25% 50%

10% 25% 50%

Percentage base colors are oversprayed with transparent green which graduates in density from 5% to 50%.

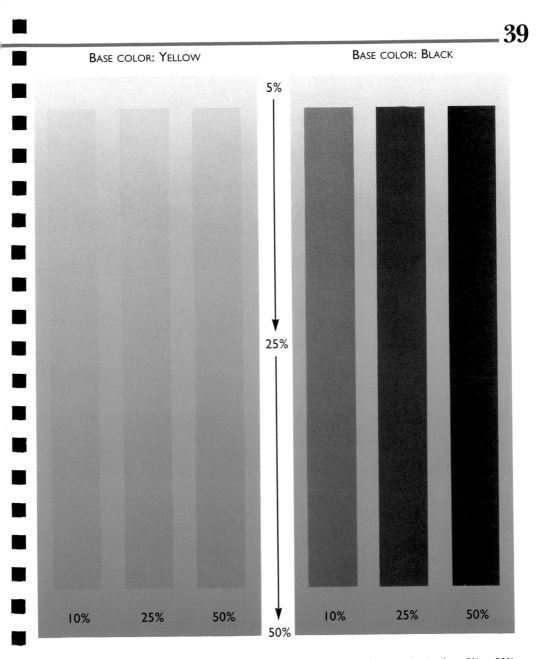

BASE COLOR: YELLOW

BASE COLOR: BLACK

5%

25%

50%

10% 25% 50%

10% 25% 50%

Percentage base colors are oversprayed with transparent green which graduates in density from 5% to 50%.

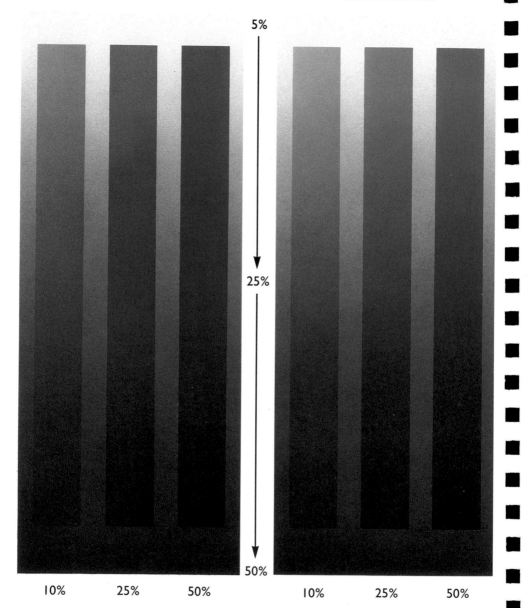

Percentage base colors are oversprayed with transparent black which graduates in density from 5% to 50%.

BASE COLOR: YELLOW BASE COLOR: GREEN

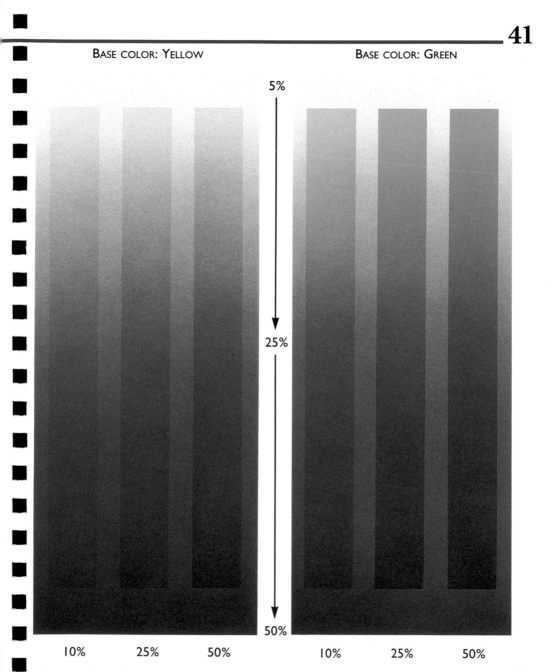

5%

25%

50%

10% 25% 50% 10% 25% 50%

Percentage base colors are oversprayed with transparent black which graduates in density from 5% to 50%.

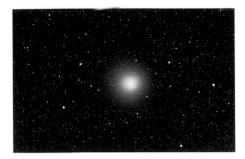

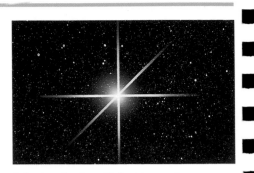

Starburst on black background

1 Dots of opaque white are sprayed using a splattercap nozzle. "Flare" is added by over-spraying with white through a standard nozzle.

4 Further detail is added to the star by repositioning the mask diagonally so that it intersects the star at its center. Opaque white is then oversprayed.

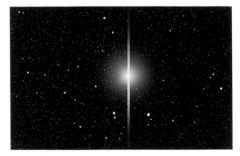

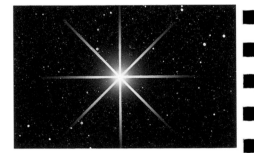

2 Lines radiating from the center of the star are sprayed using opaque white and a mask of acetate or film. The density of white is graduated from the center of the star.

5 The mask is rotated 90° and opaque white is oversprayed, graduating the white away from the center of the star.

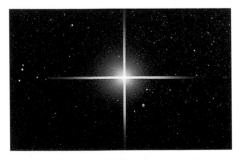

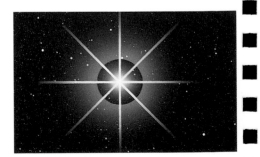

3 The mask is rotated 90° and opaque white is oversprayed, starting at the center of the star and graduating the density of the white.

6 The "halo" around the star is added by spraying an area of graduated white around a circular film mask which has been positioned over the center of the star.

Textured highlight
Opaque white sprayed through an open-weave fabric.

Hard-edge linear highlight
Pigment is removed by scraping with the edge or tip of a scalpel blade.

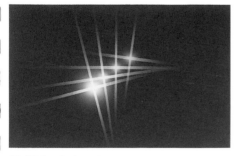

Multiple starburst
Opaque white sprayed through a repositionable film or acetate mask. The density of the white is reduced for each successive starburst.

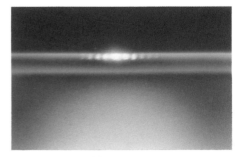

Multiple dot highlight
Dots can be applied in opaque white using a sable brush or "lifted out" with a pencil-type eraser. "Flare" is added by overspraying with white.

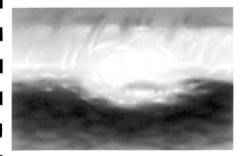

Uneven soft highlight
Surface pigment has been removed using a pencil-type eraser. The amount removed is varied by controlling the pressure of the eraser.

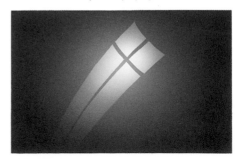

Window highlight
The shape of the window is cut in film or acetate, and a graduated area of opaque white is sprayed through it. "Flare" can be added by overspraying with white after removing the mask.

Granite

I Initial texture applied using a splattercap nozzle and diluted blue-black ink, sprayed at normal pressure.

Sandstone

I Initial texture produced by spraying a mixture of raw yellow ocher and burnt ocher ink through a standard nozzle at 30% of normal pressure.

2 Texture built up by overspraying several times using a splattercap nozzle and by dabbing with paper towel between each application until required density is reached.

2 Texture built up by overspraying several times, at 30% pressure, until required density is reached.

3 Surface modeling built up by overspraying with graduated transparent blue-black ink through a standard nozzle.

3 Darker lines and surface modeling produced by overspraying with graduated transparent burnt umber, at normal pressure using a standard nozzle.

Marble

1 Mixture of white, raw yellow ocher and process magenta sprayed at full pressure through a standard nozzle.

Brick

1 Mixture of burnt ocher and burnt umber ink sprayed through a standard nozzle at 30% of normal pressure.

2 Linear detail introduced by spraying the same color mixture at reduced pressure, and by keeping nozzle nearer to artwork surface.

2 Same color mixture oversprayed at normal pressure. Transparent graduated blue-black ink oversprayed.

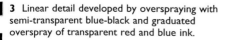

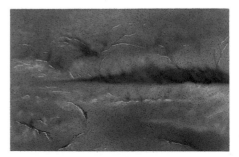

3 Linear detail developed by overspraying with semi-transparent blue-black and graduated overspray of transparent red and blue ink.

3 Linear detail developed using transparent blue-black. Texturing developed using pencil-type eraser and linear highlighting scratched out with the tip of a scalpel blade.

Pine

1 Base color is a mixture of white and raw yellow ocher sprayed through a standard nozzle at normal pressure.

Teak

1 Mixture of transparent burnt umber and burnt ocher sprayed through a standard nozzle at normal pressure.

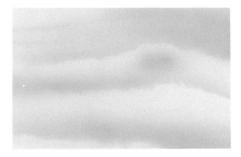

2 Mixture of transparent raw yellow ocher and burnt ocher sprayed over a torn-paper mask, the spray graduating away from the mask. 1 to 3 applications.

2 Graduated overspray of mixture of transparent process magenta and burnt umber ink.

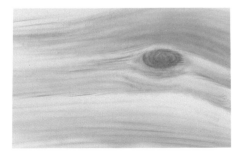

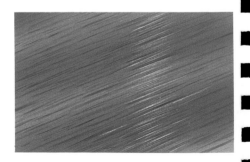

3 Tonal strength and linear detail built up with a freehand overspray of same color. Hard linear detail applied with a fine sable brush.

3 Linear detail added by spraying very close to artwork surface with reduced air pressure, and emphasizing with a sable brush. Grain highlighted by scratching with the tip of a scalpel blade.

Oak

1 Transparent base of yellow ocher and burnt ocher sprayed at normal pressure through a standard nozzle.

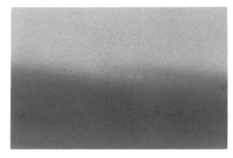

Rosewood

1 Mixture of yellow ocher and burnt ocher sprayed at normal pressure over a base of raw yellow ocher.

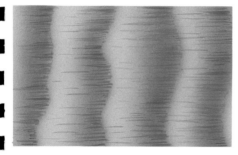

2 Graduated overspray of transparent burnt umber with linear detail added using a fine sable brush.

2 Darker stripes oversprayed with a mixture of transparent burnt umber and cobalt blue, using a standard nozzle at normal air pressure.

3 Soft linear detail oversprayed in burnt umber with nozzle kept close to artwork. Glaze of transparent burnt umber and red oversprayed, and soft highlights made using a pencil-type eraser.

3 Linear detail built up by applying a mixture of burnt umber and cobalt blue with a sable brush. Highlights made with the tip of a scalpel blade.

Gold

I A mixture of transparent process yellow and raw yellow ocher is sprayed in graduated tones, using a standard nozzle at normal pressure.

Chrome

I Dark tonal stripe sprayed using transparent blue-black, keeping nozzle close to artwork surface.

2 Tonal areas strengthened by overspraying with transparent burnt umber and burnt ocher, diluted by 50%.

2 Central stripe strengthened by overspraying with blue-black. Graduated tonal area sprayed below central stripe.

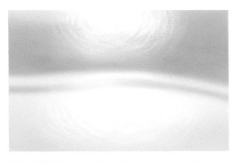

3 Soft highlights produced by using a pencil-type eraser. Eraser moved in a circular motion while gradually reducing downward pressure.

3 Graduated tonal area of dilute cobalt blue sprayed from the top. Soft linear highlights radiating from central starburst made using a pencil-type eraser.

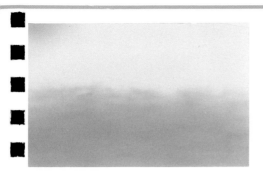

Copper
1 Transparent burnt ocher diluted by 50% and sprayed to indicate general tonal areas.

Aluminum
1 Graduated tonal areas of transparent blue-black ink sprayed using a standard nozzle at normal pressure.

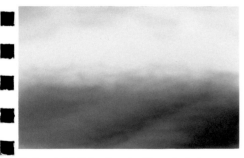

2 Tonal detail developed with graduated overspraying, using mixture of transparent burnt ocher, burnt umber and cobalt blue.

2 Linear texturing achieved by scraping with the tip of a scalpel blade. Graduated tonal area then partially oversprayed.

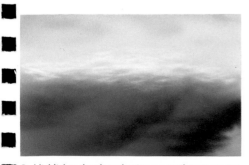

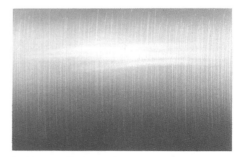

3 Highlights developed using a pencil-type eraser. Copper tarnish suggested by overspraying with mixture of opaque cobalt blue and process yellow.

3 Linear highlights made using a pencil-type eraser. Highlight flare produced by graduated overspraying with opaque white gouache, using a standard nozzle at normal pressure.

Light skin

I Lightest skin tone established using mixture of white, raw yellow ocher and process magenta.

Dark skin

I Darkest tonal area of skin indicated with a graduated spray of transparent burnt umber plus black.

2 Mid-tones developed using same color mixture plus burnt umber. Skin pores suggested with freehand spots and lines of color.

2 Mid-strength tonal areas of skin built up by overspraying with same transparent color mixture plus magenta.

3 Transparent burnt umber plus black used for darker areas. Skin color warmed by overspraying with mixture of transparent red and yellow ocher.

3 Overall skin color warmed by overspraying with mixture of transparent raw yellow ocher plus magenta. Wrinkles and highlights suggested using pencil-type eraser.

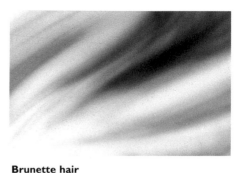

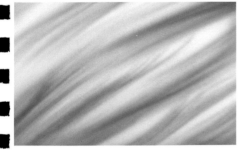

Blond hair

I Graduated areas of the lightest color are sprayed using white mixed with raw yellow ocher.

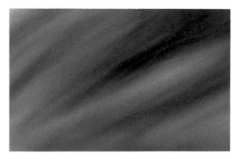

Brunette hair

I Graduated areas of darkest color sprayed with a mixture of transparent burnt umber and black.

2 Graduated streaks of transparent raw yellow ocher plus burnt umber are sprayed in several passes to establish form.

2 After linear texturing with a pencil-type eraser, a transparent glaze of mid-brown is oversprayed.

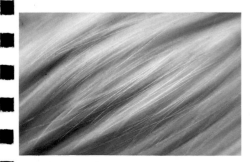

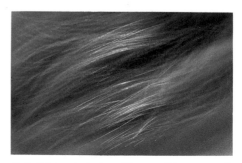

3 Darker areas developed by overspraying with mixture of burnt umber and ultramarine. Highlights made using pencil-type eraser and scratching with the tip of scalpel blade.

3 Soft linear texturing with a pencil-type eraser is oversprayed with transparent light brown. Hard linear highlights are scratched with the tip of a scalpel blade.

Ripples
1 General tonal areas blocked in using dilute mixture of transparent cobalt blue and green.

Droplets
1 Graduated tonal background sprayed using a mixture of cobalt blue, green and black ink.

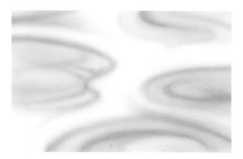

2 Darker linear tonal areas developed by overspraying several times with the same color mixture.

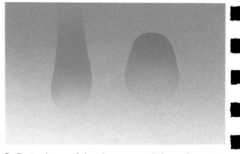

2 Basic shape of droplets sprayed through a cut-film mask, using a mixture of cobalt blue and green.

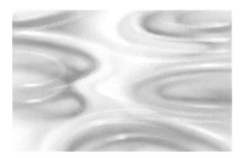

3 Darkest tonal areas developed further by overspraying. Dilute cobalt blue oversprayed in lighter tonal areas. Linear highlights picked out with a pencil-type eraser.

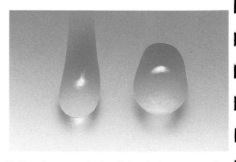

3 Droplets remasked and the shadows sprayed using the background color mixture. Intense highlights scraped out with a scalpel and softened with a pencil-type eraser.

Using opaque medium
1 Graduated sky background sprayed using a mixture of cobalt blue and white gouache at normal pressure.

Using transparent medium
1 Graduated sky background oversprayed several times using a mixture of transparent cobalt blue and process cyan ink.

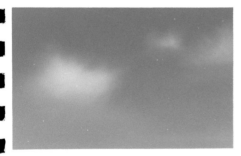

2 General form of clouds sprayed using opaque white. Strength of white built up with several oversprays, allowing each layer to dry before applying the next.

2 Darker tonal areas of clouds oversprayed using a dilute mixture of transparent cobalt blue and black ink.

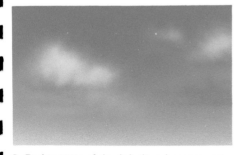

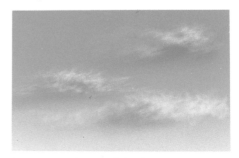

3 Darker areas of clouds built up by overspraying freehand with a mixture of opaque white, cobalt blue and black gouache.

3 Lighter tonal areas of clouds made using a pencil-type eraser. Subtle variations are produced by controlling the pressure of the eraser.

Mark Taylor – *Flood*

THIS PAINTING, originally commissioned for a paperback book cover, was painted on gesso-primed hardboard using liquid acrylic inks. A detailed pencil drawing was first produced on type-detail paper which was then transferred to the board using graphite paper. The aim was to create the effect of leaves floating on the surface of the water, whilst giving a suggestion of depth to the water.

◀ *The reflection of the figure was initially sprayed using a hinged acetate mask. The mask was lifted slightly from the artwork surface whilst spraying in order to avoid producing a sharply rendered edge.*

▲ *After all the color spraying was completed, the highlights in and around the leaves were produced by scratching-back with a scalpel blade. Softer highlights in the water were produced using a pencil-type eraser.*

▶ *A cut-film mask protected the leaves whilst the water ripples were sprayed. The texture in the leaves was then developed by spraying the color with a low air pressure, and stippling with a brush.*

◀ *The swirling water ripples were produced with repeated freehand overspraying of transparent dark green ink to build up tonal strength. Transparent blue was then oversprayed to suggest the sky's reflection.*

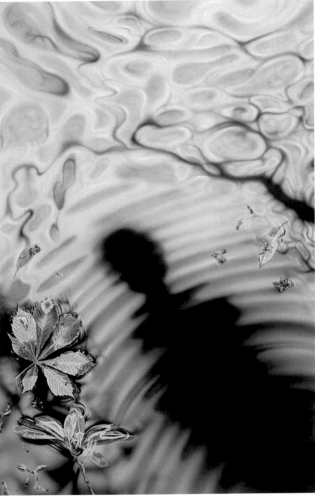

Shiny

1 Using repositionable cut masks, a mixture of red, cobalt blue and black ink is sprayed to establish the basic folds in the material.

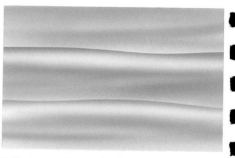

Matt

1 Basic tonal areas established by spraying a mixture of green and black ink through a cut-film mask.

2 Tonal areas developed and strengthened with freehand overspraying within the masked areas.

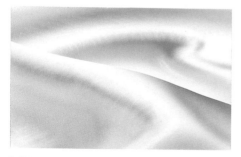

2 Darker tonal areas developed by repeated overspraying within the masked areas.

3 With masking removed a dilute mixture of red and ultramarine blue is oversprayed. Highlights are applied using a pencil-type eraser.

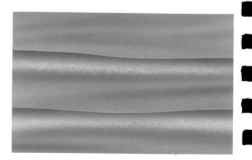

3 Darkest tonal areas oversprayed. With masking removed soft textured highlights are applied using a pencil-type eraser. Highlights are tinted by overspraying with diluted color.

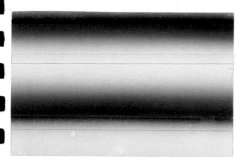

Shiny

1 A graduated spray of diluted black ink is sprayed through a cut-film mask. Sections of the mask are removed in sequence, working from dark to light.

Matt

1 General tonal areas and suggestion of texture sprayed using blue-black ink through a standard nozzle at 50% normal air pressure.

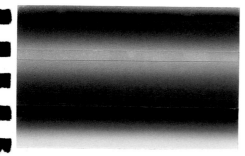

2 Areas to have an intermediate tonal strength are exposed and sprayed with a graduated spray of black ink.

2 Strength of tone and texture developed by repeating overspraying at 50% pressure.

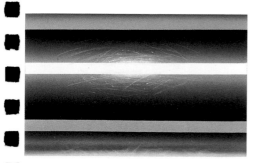

3 Lightest tonal areas are exposed and sprayed. Masking is removed and "scuffs" and "scratches" are applied using a pencil-type eraser and scalpel blade tip.

3 Darkest tones developed by repeated overspraying. Linear tonal areas sprayed keeping nozzle close to the artwork surface. Subtle highlighting picked out using the tip of a scalpel blade.

Cut film

I The film mask is cut with a scalpel blade and the area which will be darkest is exposed and sprayed. The film mask produces a hard-edged effect.

2 The masked areas are exposed and sprayed with graduated color in sequence, working from dark to light. Each area is sprayed with fewer passes than the previous one.

3 The lightest tonal areas are sprayed last and the masking removed.

Movable acetate

I Acetate is cut with a scalpel or scissors and oversprayed while being held flat against the artwork surface.

2 Variations in the edge quality are achieved by lifting part or all of the mask away from the surface before spraying, and by holding the airbrush at different angles and heights.

3 Further variations can be produced by moving the mask, by repeated sprays and overlapping previously sprayed areas.

Masking fluid
I Masking fluid can be applied with brush or pen. Test it on the surface to be used beforehand as it can be difficult to remove from some soft surfaces.

Fabric
I Fabric is taped over the area to be sprayed, which has previously been tinted with dilute yellow ocher.

2 Once dry the masked areas can be oversprayed, and the dry fluid removed by rubbing with a finger or soft eraser.

2 The area is oversprayed several times with a mixture of burnt umber and black ink until the required dark tone is reached.

3 Textures can be developed and elaborated with repeated masking and overspraying using transparent colors.

3 With the masking removed the surface can be modeled with freehand overspraying. Highlights can be picked out using a scalpel blade.

Smooth board

Smooth watercolor paper

Acrylic primed canvas

Textured watercolor paper

Acetate (can be placed over different colors.)

Not surface watercolor paper

Metallic surface

Primed, open-weave fabric

Hardboard

Primed sandpaper

Wood

Board textured with acrylic gesso

CONTRASTING TEXTURES

Catherine Diez-Luckie – *A Frog Asks "How?"*

CUT-FILM MASKING and loose acetate masking have been combined with texturing in order to emphasize the difference in form and surface characteristics of the various elements in this composition.

▲ *Loose acetate masking has been used to suggest the underlying dark wood grain, which has then been oversprayed with very fine linear overspraying, which in turn has been highlighted using an eraser, and linear detail added with a fine brush.*

▶ *The shadowed area of the tabletop has been produced by overspraying with a transparent sepia color, using an acetate mask so as not to give the shadow a sharp edge.*

▼ *Inside a cut-film mask, the form of the frog has been sprayed freehand in ochers, browns, and greens. Texturing and highlighting have been applied by stippling opaque color with a brush.*

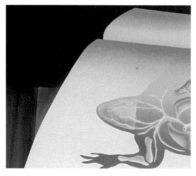

▲ *The crispness of the paper's edge and the book illustration have been emphasized by using cut-film masking, with flat and gradated color being sprayed without any surface texturing.*

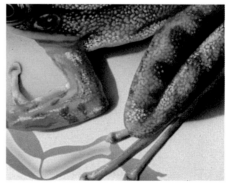

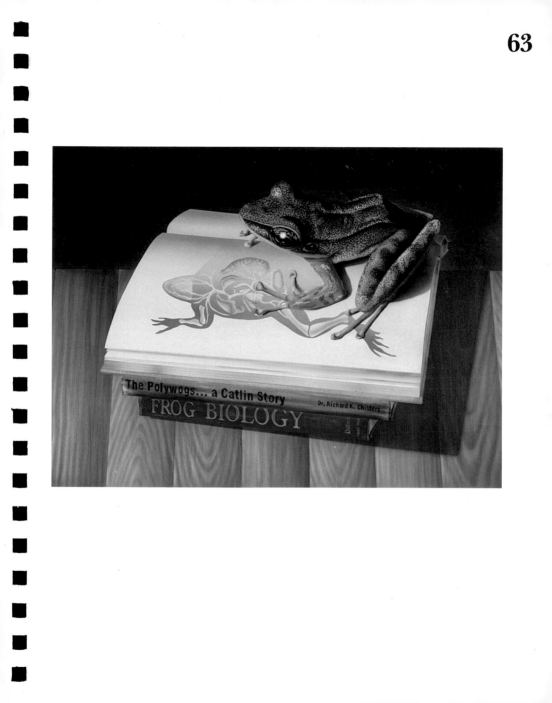

CREDITS

Quarto Publishing would like to thank the artists who have kindly allowed us to reproduce their work in this book.

Adrian Chesterman appears by courtesy of the illustrators' agent The London Art Collection, with thanks.

All other images are the copyright of Quarto Publishing plc.

Senior Editor
Kate Kirby

Senior Art Editor
Clare Baggaley

Picture Research Manager
Giulia Hetherington

Designer
Sally Bond

Color charts
Mark Taylor

Editorial Director
Mark Dartford

Art Director
Moira Clinch

Typeset by Central Southern Typesetters, Eastbourne
Originated by Bright Arts (Singapore) Pte Ltd
Printed by Leefung-Asco Printers Ltd, China